Cézanne

Ginger Jar

Paul Cézanne (1839–1906) was a French Post-Impressionist painter. His works and ideas were integral influences in the development of 20th century modernism—in particular abstract art and cubism. Characterized by short, hatched brushstrokes and structural planes of color, Cézanne's works are meditations on nature, form, perception, and space.

Artwork:
Paul Cézanne, 1839-1906
Ginger Jar (Pot de Gingembre), c. 1895
Oil on canvas, 73.5 × 60.5 cm
The Barnes Foundation, Philadelphia
Photo: ARTOTHEK

Published by teNeues Publishing Company
© teNeues Publishing Company

www.teneues.nyc